Skira**M**ini**ART**books

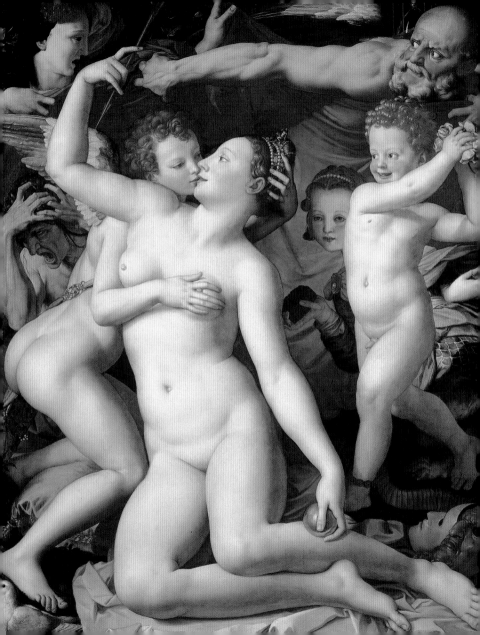

Flaminio Gualdoni

FEMALE NUDE

front cover
Kallipigian Venus (detail)
Marble, height cm 152
Museo archeologico Nazionale,
Naples

Skira editore
SkiraMiniARTbooks

Editor
Eileen Romano

Design
Marcello Francone

Editorial Coordination
Giovanna Rocchi

Layout
Anna Cattaneo

Iconographical Research
Alice Spadacini

Editing
Maria Conconi

Translation
Robert Burns for Language
Consulting Congressi, Milan

First published in Italy in 2008
by Skira Editore S.p.A.
Palazzo Casati Stampa
via Torino 61
20123 Milano
Italy

www.skira.net

Printed and bound in Italy.
First edition

ISBN 978-88-6130-539-7

Distributed in North America by
Rizzoli International Publications,
Inc., 300 Park Avenue South,
New York, NY 10010.
Distributed elsewhere in the world
by Thames and Hudson Ltd.,
181a High Holborn, London
WC1V 7QX, United Kingdom.

facing title page
Bronzino
An Allegory with Venus and Cupid,
1544-45
Oil on wood, cm 146.5 x 116.8
National Gallery, London

on page 90
Raphael (Raffaello Sanzio)
Portrait of a Young Woman
(detail), 1518-19
Oil on wood, 85 x 60 cm
Galleria Nazionale d'Arte Antica,
Palazzo Barberini, Rome

Archivio Skira
© The Bridgeman Art Library /
Archivi Alinari, Firenze
© Archivio Luciano Pedicini
© Nobuyoshi Araki 2008
© The Munch Museum /
The Munch-Ellingsen Group,
by SIAE 2008
© Man Ray Trust, by SIAE 2008
© Balthus, Pierre Bonnard, Albert
Brassaï, Martial Raysse, by SIAE
2008

Works owned by the
Soprintendenza are published
by permission of the Ministero
per i Beni e le Attività Culturali

The publisher is at the disposal
of the entitled parties as regards
all unidentified iconographic
and literary sources.

Contents

Female nude

J ean-Auguste-Dominique Ingres painted his celebrated *Valpinçon Bather* in 1808, and in 1814 *La Grande Odalisque*. In terms of style, they represent Classical figures embodying the sense of triumphant beauty of great Renaissance art. However, from the iconographic standpoint, they are nudes that have begun to free themselves from the need for an alibi based on ancient mythology and allegory to justify the portrayal of the female body in all its beauty. This marks a decisive shift in the history of art. Beauty descends from Olympus to become a human and earthly quality, and no prudish social norms can rein in the celebration of nudity as the revelation of beauty. The stage was set for Édouard Manet's scandalous *Olympia* in the latter half of the century, specifically in 1863. She was a recognisable contemporary woman portrayed in the pose of a Venus à la Giorgione or Titian.

Among the pictorial genres populating the history of art, the female nude is among the most fervid and at the same time the most controversial. Representing the very paradigm of beauty, harmony and supernatural perfection since ancient times, the female body has been and still is the object of irrational erotic desire for the universe of men. It is thus caught in the unique condition of simultaneously representing the height of idealisation and the depths of obscure and uncontrollable sensual drives.

Susanna in the Bible aroused the carnal desires of old men, as did Bathsheba, outcome of a sin for which David must bitterly atone. In the Greco-Roman world, the inexhaustible well of stories in Ovid's *Metamorphoses* narrates the punishment of Actaeon for having stolen a peek at the chaste nudity of Diana, the desire aroused in Zeus at the sight of Leda at her bath, and the eloquent symbol of Pygmalion's passion for Galatea, the perfect sculpture, the fruit of his art made woman. Ideal

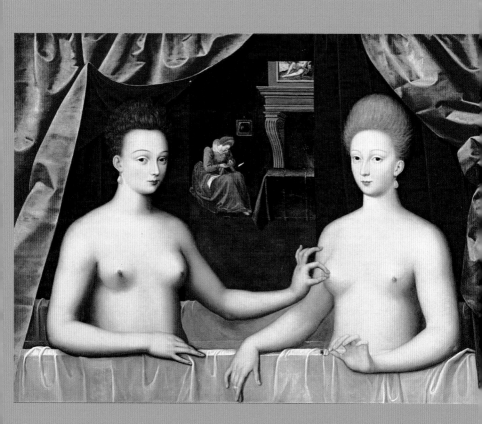

beauty is made flesh and blood and can thus become the object of true love instead of pure admiration. In the organisation of the Greek Olympus, all the goddesses represent absolute beauty, but it is Aphrodite who incarnates desired and desiring beauty. When Eris cast among the goddesses the apple of discord addressed "To the Fairest", Hera, Athena and Aphrodite all laid claim to it. Aphrodite won the preference of the judge, Paris, by promising him the most beautiful of all mortals, Helen.

There is a tenacious tradition of belief whereby in the ancient world, nudity was an everyday custom and experienced with natural ease (as we read for example in the writings of Johann Joachim Winckelmann, the eighteenth-century Neoclassical theoretician, and in those of David Herbert Lawrence in *Etruscan Places*, where he stated that "the Etruscans went a good deal naked"). It stands in a sort of ahistorical contraposition to Christian culture, where the Bible gives us the shame of nudity following the Original Sin. In reality, the polarity between the symbolic value of absolute beauty and more earthly sensual thoughts has been quite present and alive since the very origins of ancient art.

School of Fontainebleau
Gabrielle d'Estrées and One of Her Sisters, *circa* 1594
Oil on panel, 96 x 125 cm
Musée du Louvre, Paris

Nevertheless, the female body originally represented yet something else. While the history of art has handed them down to us with the name of Venus, the Great Mothers that have accompanied the human experience since Palaeolithic times with their emphatic forms or conspicuous and stylised sexual attributes refer to the mystery of generation. As the earth bears fruit from the fertilised furrow, so the woman gives the fruit of progeny. In a civilisation that was still matriarchic, the divinities took on feminine traits,

and their nudity was a positive thing, even being the object of worship. Here, what was at play was not a celebration of beauty, but a stratum of more obscure and profound meanings.

For centuries in the Greek world, the female figure was draped and stood in cultural contraposition to her male counterpart, who was nude. It was not until the end of the 5th century BC, at the time when Phidias crafted the extraordinary sculptures of the Parthenon, that the goddesses began to take on a more clear resemblance to women.

Her clothing began to adhere to her body and reveal her form in a stylistic mode called, not surprisingly, the "wet drapery" style. The divine figures ceased being hieratic, distant and superhuman, and increasingly began to assume poses and engage in situations that also belong to the human province.

Lucas Cranach the Elder
Eve, 1528
Oil on panel, 172 x 63 cm
Galleria degli Uffizi,
Florence

The turning point came with Praxiteles, a sculptor and genius of the 4th century BC, and his *Aphrodite of Cnidus*. The goddess has disrobed and is placing her clothes on a lustral vase before entering her bath, while she seems to be making an instinctual gesture of chastity with her right hand. The cultural taboo about the goddess's nudity is transformed into a sensual celebration of the onlooker's gaze, to which that chaste gesture is a response and thus a revelatory act. The goddess is making an intimate gesture, she does not offer herself to the ritual awe of her worshippers, but to a more private and intimate gaze in a completely new and different psychological framework, in a sort of intimate relaxedness that provides the emotional context for the scene. The stylistic conception is produced by an intelligent awareness of the picturesque effect of the

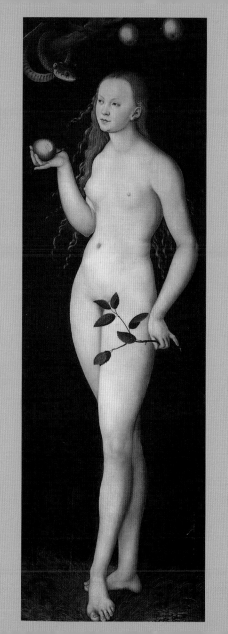

image, playing on a private pathos which from that point onward would characterise much of European art. The beauty that the artist has depicted no longer derives from its kinship with the good and the true, as had been the case up to that time, it is not an intellectual or moral quality; it is an experience that is full and gratifying in itself, it is a visual—and we might also say tactile—experience, in an initial declaration of the aesthetic autonomy of the work of art.

It is no coincidence, for that matter, that the literary tradition insists that the model for the sculpture was Phryne, a famous *hetaera* of legendary beauty and Praxiteles' lover. The theme of the humanisation of the divine thus explicitly sanctions a sensual treatment. Nor is it a coincidence that it was Phryne, protagonist of one of the most famous and most controversial paintings of the time, who in the nineteenth century definitively affirmed a direct, non-mediated view of female nudity. In 1861, just two years before Manet's *Olympia*, Jean-Léon Gérôme dedicated one of his paintings to the trial of Phryne (*Phryne before the Areopagus*), according to the tale told by the erudite Atheneus. Very wealthy and extolled by the powerful, the courtesan is accused of corrupting the public mores. She is defended by the orator Hyperides, one of her lovers. Presenting his case before the heliasts who would judge her, Hyperides senses that his words are not enough, and in a sudden theatrical flourish, strips off her clothing to deliver his main argument, the naked body of the defendant. Her breathtaking beauty wins her acquittal and Phryne is carried triumphantly to the temple of Aphrodite. The beauty of nudity, stated Atheneus and repeats Gérôme, is something that is both human and divine, standing above and beyond common morality.

From Hellenism all the way to early Christian art, there was an explosion of painted and sculpted portrayals of completely humanised

12

and often explicitly sensual nudes in mythological settings or, as we see in Pompeian painting, in scenes of mystery cults or even daily life.

The long season that stretches from the end of the period of ancient art to the cultural revivals of Humanism and the Renaissance is characterised by the very strong presence of religion. Not only is any depiction of female nudity, seen as sinful in itself, to be forbidden, but a much broader suspicion reigned regarding the very idea of images themselves. A Biblical interdiction inherited from the Judaic tradition cast a long shadow in Christian art: "Thou shalt not make unto thee any graven image, or any likeness of any thing that is in heaven above, or that is in the earth beneath, or that is in the water under the earth. Thou shalt not bow down thyself to them, nor serve them." (*Exodus* 20, 4-5). Byzantine iconoclasm and the war against images that still enflamed the extremist fringes of the Protestant Reformation in the sixteenth century grew out of discomfort with the idea of portraying anything, because creating images from matter was the prerogative of God alone, and also because the false figures of art are pleasing to and excite the senses, drawing them away from the search for Truth. Medieval art became so entrenched in this position that the very knowledge of the human body was lost, along with the canons of proportional representation that the Greeks, from Polycletus on, had left as a legacy.

The sculptors and miniaturists from the 12th century onwards were well aware of this as they dealt with iconographies—ranging from Adam and Eve to the Last Judgement—in which nudity was an essential part of the tale. Medieval masters of sculpture such as Wiligelmus and the Master of the Hildesheim cathedral created bodies that emerge from matter with difficulty, lacking proportions or articu-

lation; these sculptors seem to be saying that the human body is a drama of our earthly life and not an image of the divine. It is a burden from which only death will free us and not a masterpiece of creation.

Yet one century later, concern with direct observation of nature and the choice to take cues from ancient art in conceiving complex figurations began to gain affirmation. The great sculptors of the cathedrals and the Limbourg brothers' miniatures of the *Très riches heures* of the Duke of Berry, absolute masterpiece of late Gothic art, resumed their study of the human body both through direct observation and also by means of classical models, and to justify female nudity in the name of purity, of a virginal idea of the body and the symbolisation of "nuda veritas". The Gothic nudes of northern European art are the forebears of those with the elongated, sinuous bodies that would long populate German and Flemish art until Dürer's discovery in Venice of just how much knowledge of human anatomy was contained in Italian art.

Rembrandt
Danae (detail), 1636
Oil on canvas,
185 x 203 cm
The State Hermitage
Museum, St. Petersburg

Then came the Italian Renaissance and with it not only the adoption of the ancient as a model, but even a sort of cult of antiquity and its works. While we owe to the fifteenth-century generations—and foremost among them to Donatello and Sandro Botticelli—the idea of reproposing the nude in all its figurative power as a contemplation of beauty, it was not until the end of the century and the arrival of the ground-shaking genius of Leonardo da Vinci that the approach was definitively reoriented. Leonardo associated with his study of the art of the past a passion for direct observation that included the dissection of real cadavers, having as his only significant predecessor the Bolognese

14

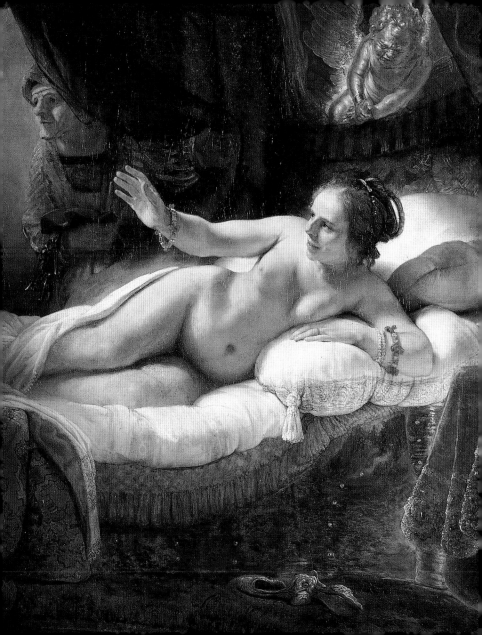

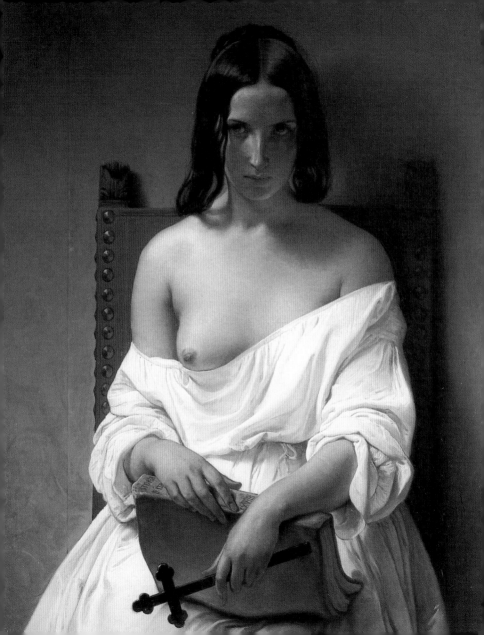

anatomist Mondino de' Liuzzi, who published a treatise in 1316 titled *Anothomia*. In this work, Liuzzi explained that humans have an erect posture because they "possess a perfect form that they share with the angels and with the minds that rule the universe, and thus must be oriented upwards in accordance with the universe, oriented upwards. (…) Humans have received an erect form and stature to satisfy their ultimate purpose, because they are destined to achieve understanding. For this reason people use their senses and especially their sight, as we have seen in the introduction to the *Metaphysics*. For this reason the eyes and the brain, contained in the head, were set in a position where they can employ various sensory modes."

Francesco Hayez
Meditation on the History of Italy, 1851
Oil on canvas,
92.3 x 71.5 cm
Civica Galleria
d'Arte Moderna, Verona

With his *Vitruvian Man*, Leonardo rediscovered the organic unity of the human body in a world in which Cennino Cennini's early fifteenth-century manual, *Libro dell'arte*, still carried a great deal of weight. This work explained that the body has to be composed in a modular fashion using the basic unit of measurement of the "face", which is one ninth of the total. The torso then was three "faces" long in the schematic Byzantine manner. According to Leonardo, "Vitruvius the architect puts in his work on architecture that by nature the measurements of man are distributed in this way". Thus, starting from the classical canons, he once again worked out the mathematical proportions of the human body, giving us "the most beautiful spectacle in this world", according to the words of Pico della Mirandola in his contemporary work *De Hominis Dignitate.* With Leonardo, author of the refulgent *Leda*, and with the marvellous generation of Giorgione, Michelangelo, Raphael, Titian and

Giovanni Bellini, the first direct knowledge of the human body nourished an approach to thinking about beauty that once again placed the human figure at the centre in a true rebirth of ancient grandeur.

Certainly, the art of sacred inspiration still poses unbreachable limits on the return of the female nude in all her splendour. But alongside images whose symbolic value allows an explicit treatment of the theme (from the iconography of the evangelical sinner Mary Magdalene to the allegories of Truth, Vanity and Lust: Truth is naked in that it is a revelation that must not be concealed; Vanity is naked in that beauty is a gift that time takes away; and Lust in that earthly desire distracts from the quest for eternal salvation), there are others directly inspired from classical mythology that won favour among a private clientele who gained increasing stature alongside their ecclesiastical counterparts. Ovid's *Metamporphoses*, an oft copied and published work, were very often the source of subjects to portray.

Pierre Bonnard
Nude at Her Bath, 1931
Oil on canvas,
120 x 110 cm
Musée national d'Art
moderne – Centre Georges
Pompidou

Raphael could cite the Hellenistic motif of the *Three Graces* in a painting that he would later resume in the Farnesina in Rome, depict Adam and Eve as two youths in the fullness of their physical splendour in the Room of the Segnatura in the Vatican, heart of Catholic religious culture, and celebrate the triumph of the ancient in the *Galatea* in the Farnesina. His *Galatea* is an evocation of the past and at the same time a quite concrete allusion to the present, provided it is true, as many claim, that the protagonist in the painting closely resembles Imperia, mistress of the patron Agostino Chigi and renowned courtesan. Likewise many recognise the face of Beatrice Ferrarese in Raphael's *Fornarina*, another nude that the artist—whom Vasari presents to us as well loved by

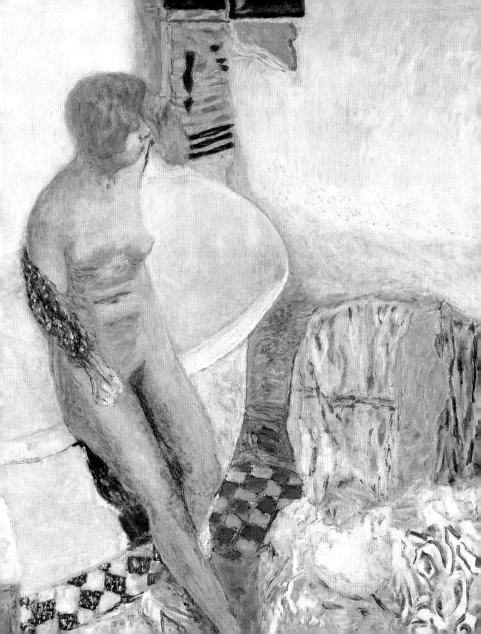

women and a devotee of "exaggerated amorous pleasures"—painted toward the end of his days.

The women of Titian and Giorgione are strongly feminine goddesses, full-bodied Venuses in whom, as the writer Giuseppe Rovani described it, "the flesh is truly flesh; it swells with softness and blood". The models are often the painters' lovers. With Titian and Tintoretto in mind, Diego Velázquez in Rome painted *Venus at her Mirror*, resting comfortably on her bed and seen not from the front but from behind. His lover Flaminia Triva is, to put it briefly, less and less divine and more and more feminine, brilliantly captured in an act of private coquetry. The same act inspired Giovanni Bellini in his famous *Naked Young Woman in Front of the Mirror*, and was also employed in a triumph of sensual and opulent flesh by Rubens.

The view of the female nude from behind actually has its own ancient tradition. The *Aphrodite Kallipygos*, a Hellenistic theme with many known versions, lifts her garments to reveal, with feigned candour and sincere guile, the beautiful buttocks that gave her her name. A perhaps more famous scene in the Villa dei Misteri in Pompeii depicts a woman from behind, and in the most typical iconography, we find one of the three Graces in the same position. In addition to the Venus of Velázquez, other paradigmatic works are based on this daring and explicit viewpoint, referring back and forth and evoking one another in an infinite interplay of allusions.

Ingres's *La Grande Odalisque* is an homage to both Titian and Velázquez, while just a few decades earlier, François Boucher had fashioned into a licentious motif that which his predecessors had approached by more indirect paths.

20

With the unfolding of the nineteenth century, art gradually freed itself of the last vestiges of mythological alibis cloaking the subject and could directly address the issue of the truth of the female nude.

Certainly, celebrated French masters of the likes of Cabanel and Bouguereau still resorted to mythological titles for their titillating nudes, and other took refuge in the exoticism of harems and Turkish baths. But Émile Zola wrote of Cabanel's Venus that "the goddess, drowned in a river of milk, resembles a delicious courtesan, not made of flesh and bone—that would be indecent—but of a sort of pink and white marzipan". The limit is there, and only a scroll alongside the work tells us if we are on this side or that side of the common sense of modesty. The ruse can't hold up any longer.

This appeared quite clearly at the Parisian Salon of 1847. Auguste Clésinger presented his *Femme piquée par un serpent* ("Woman bitten by a serpent"), a sculpture showing a nude woman writhing on a bed of roses, with a snake twisted around her wrist. The anatomy is very realistic since the work is a cast of the then recognisable Apollonie Sabatier, a notable in the Parisian *demi-monde*. It caused an enormous uproar, and little was accomplished by the defence waged by Théophile Gautier, who stated that at last we find before us "a head and a body of our times, in which each of us can recognise our own lover".

The work that would finally and definitively sunder the limit was Manet's *Olympia*. The discerning viewer may recognise Victorine Meurent, the "redhead with beautiful dark eyes", protagonist also of *Déjeuner sur l'herbe* and other works by the artist, a beauty of diabolical fame well known all over Paris.

With explicit references to Giorgione and Titian, the artist gives us the nude figure of a woman who looks the viewer directly in the eye

Martial Raysse
Nu jaune
(detail), 1964
Acrylic and oil on plywood,
96.5 × 130 cm
Luigi and Peppino Agrati
Collection

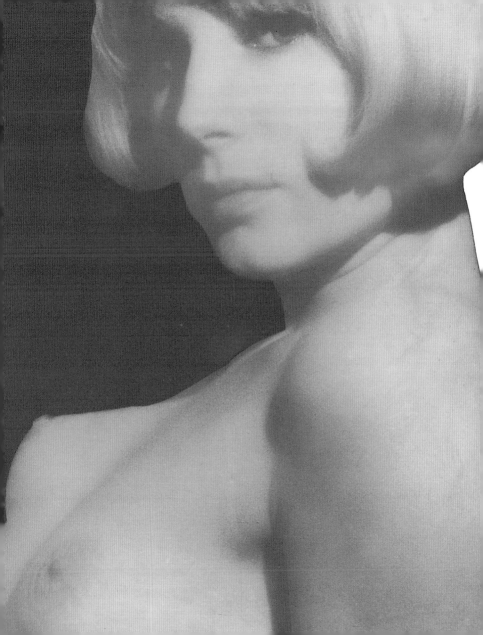

with unconcealed pride and self-confidence. The veil of classical imagery is shredded; there is no other justification for this nudity except its exposure to the gaze of the onlookers. Even Gautier shrank back this time and accused the artist of seeking to shock at all costs with his work. It was Zola who discerned the sense of upheaval, observing that it was truly flesh, a young woman that the artist had thrown onto the canvas in her youthful yet already fading nudity. He added "When other artists paint Venus they correct nature, they lie. Manet asked himself why he should lie. Why not tell the truth? He has introduced us to Olympia, a girl of our own times".

The taboo is broken. And fortunately a work that was nearly contemporary and definitively, crudely realist such as Courbet's *The Origin of the World* was destined to remain secret for many decades to come, first in the collection of the patron, the Ottoman diplomat Khalil-Bey, and then in those of a series of owners, the last being the great psychoanalyst Jacques Lacan. The owners tended to keep it hidden under another painting, such is its immediate power to disturb, even today, more than one beholder.

Hence the Venuses, Magdalenes and Maenads left the stage for good, while real women made their entrances. They might be the prostitute lover of Alfred de Musset's Rolla, painted by Henri Gervex, or lovers or models captured in moments of absolute intimacy, even in the most private ceremony of the toilette (although the bath was also a theatre for Diana, Bathsheba and the *Aphrodite of Cnidus* if we really come to think of it). Take for example the paintings of Edgar Degas and Henri de Toulouse-Lautrec, of Pierre-Auguste Renoir and Pierre Bonnard, who lead us into the twentieth century.

The twentieth century, the century of the desperately sensual lovers of Amedeo Modigliani and the monumental and classical *Bathers* of Paul Cézanne, a famous brothel scene, *Les Demoiselles d'Avignon* by Pablo Picasso, and the neurotic and morbid eroticism of Edvard Munch. The twentieth century, which seeks to recover, especially between the two world wars, a foundation in a renewed classical ideal. But regarding the female nude, it has to try to keep pace with a crazed evolution in our way of looking, where the boundaries of the beautiful and the licitly viewable—in this century of avant-garde provocations—are constantly shifting.

On the level of clarity and truth of representation, painting and sculpture meet with a formidable competitor, and initially one that is apparently invincible: photography. If, as it has been often written, photographs of nude females are inexorably caught up in the very origins of the technique, and if again, in the early years of the century, photographers like Galdi and Plüschow ran afoul of the law because they put nude photos of men into circulation, with masters like Man Ray and Edward Weston the photographic female nude reached an extremely high level of aesthetic quality and quickly assumed the recognised dignity of art. It is quite true that still in 2003 the photographs by Nobuyoshi Araki were destroyed en route to an exhibition by a zealous transporter who considered them pornographic, and in 2007, Nan Goldin earned accusations of obscenity for her images, but these are isolated episodes.

This is partially because the definitive synthesis of the theme was stated, in a playfully provocatory and conceptually brilliant way, by Piero Manzoni in 1961. By signing and dating the bodies of his provocative models, he made the nude female as such and in all rights, a work of art. Today's Aphrodites are flesh and blood women.

Works

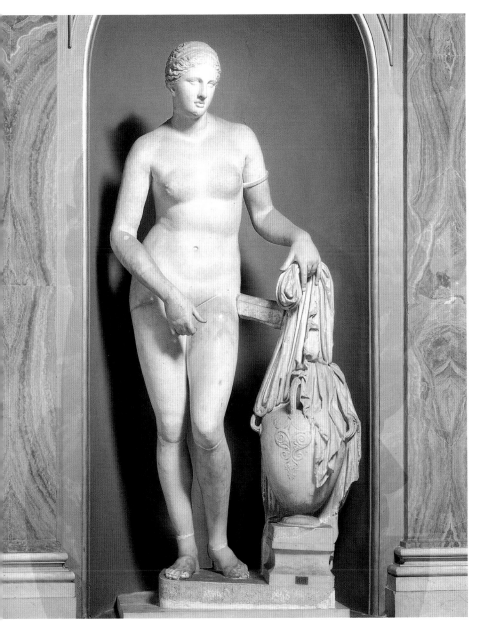

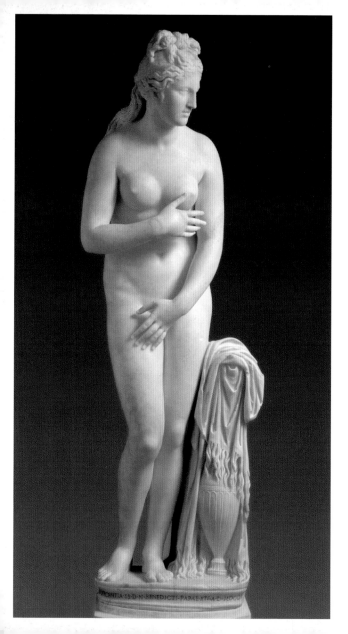

Previous page
1. *Knidian Aphrodite*
(*"Colonna Venus"*)
Roman copy of the original
by Praxiteles (*circa* 350 BC),
first half of 2ⁿᵈ century AD

2. *Capitoline Venus*
Roman copy of the original by
Praxiteles from the 4ᵗʰ century
BC, Antonine Age
(142-93 AD)

3. Sandro Botticelli
Birth of Venus,
(detail) 1484

Following pages
**4. Marie Guilhelmine
Benoist**
Portrait of a coloured woman,
1799-1800

**5. Raphael
(Raffaello Sanzio)**
Portrait of a Young Woman
(*La Fornarina*), 1518-19

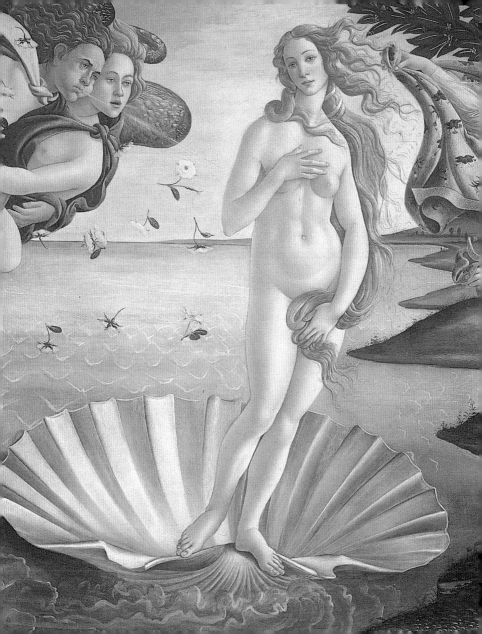

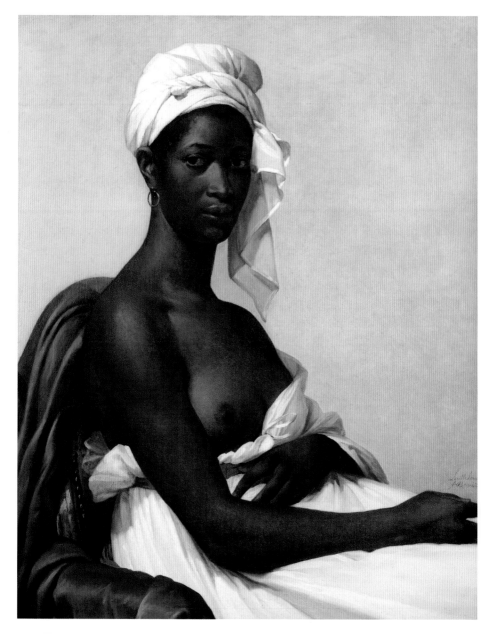

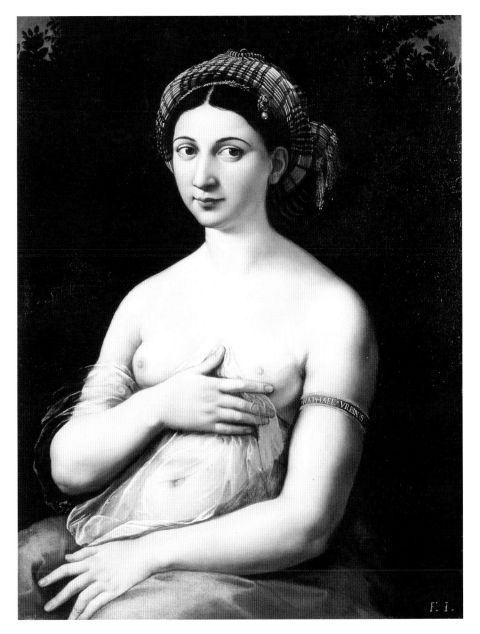

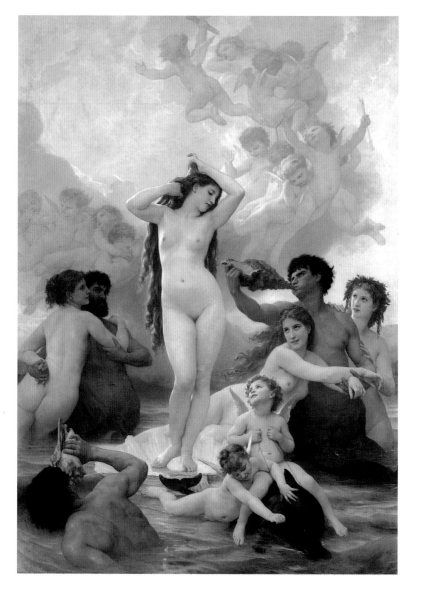

32

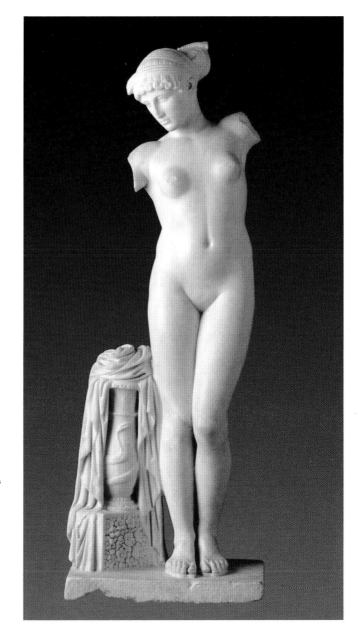

6. William Adolphe Bouguereau
The Birth of Venus, 1879

7. Pasiteles or Stephanus
Esquiline Venus,
circa 46-4 BC

Following pages
8. Antonio Canova
The Graces, 1813-16

9. Pieter Paul Rubens
The Three Graces, 1638 (?)

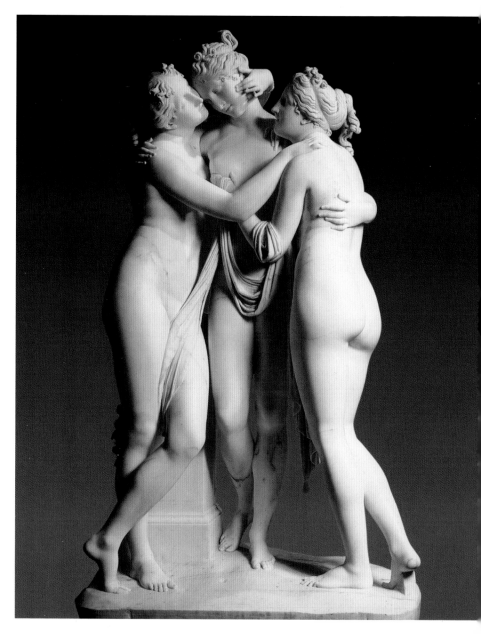

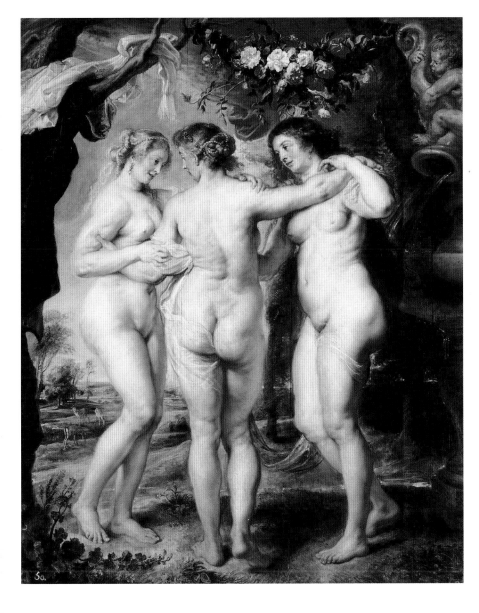

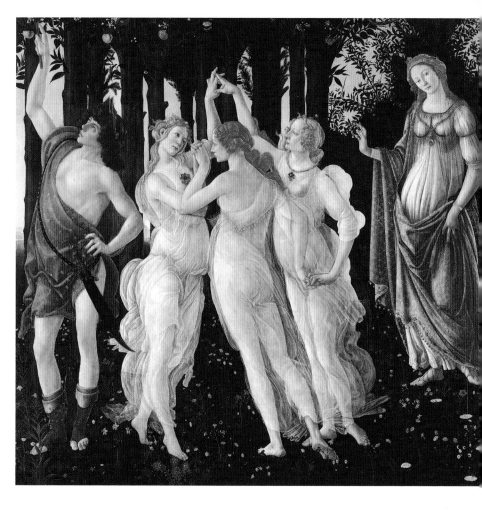

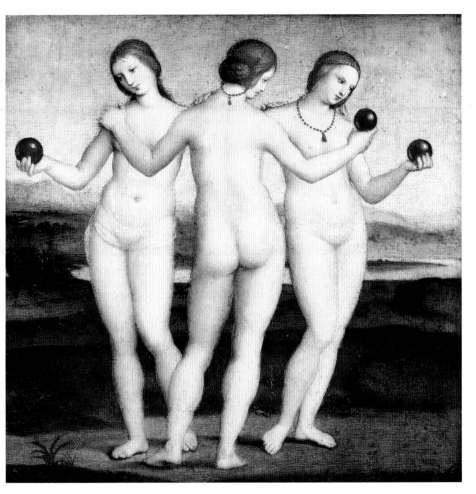

10. Sandro Botticelli
Allegory of Spring, 1481-82

**11. Raphael
(Raffaello Sanzio)**
The Three Graces, 1505

Following pages
12. Jean-Léon Gérôme
Pygmalion and Galatea,
circa 1890

13. Jean-Léon Gérôme
Pygmalion and Galatea,
circa 1890

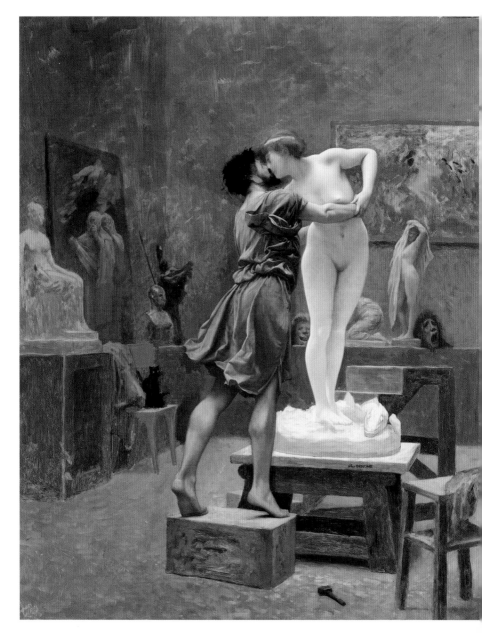

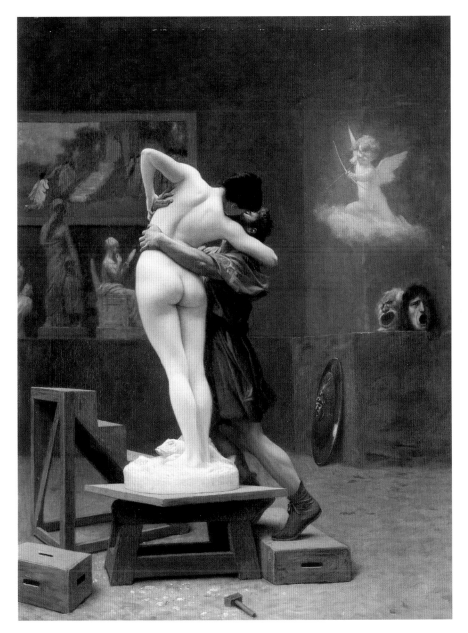

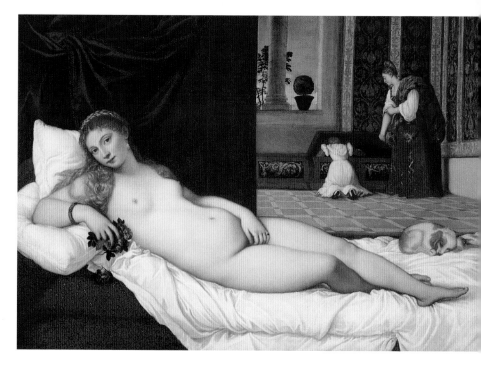

**14. Titian
(Tiziano Vecellio)**
Venus of Urbino, 1538

15. Édouard Manet
Olympia, 1863

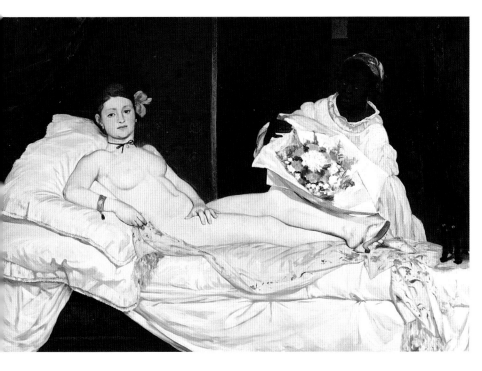

41

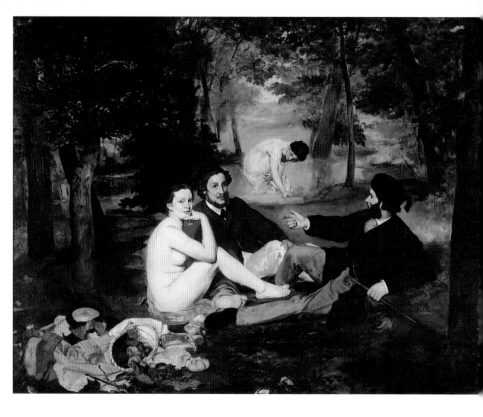

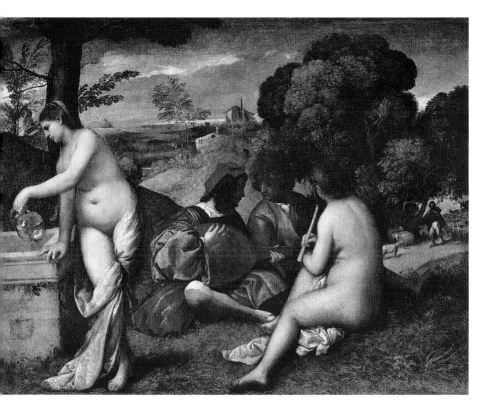

16. Édouard Manet
Le déjeuner sur l'herbe, 1863

17. Titian
(Tiziano Vecellio)
Country Concert, circa 1510

43

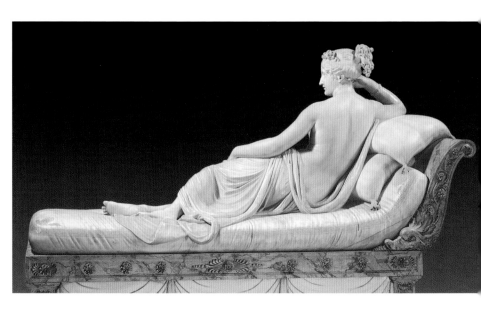

18. Antonio Canova
Pauline Bonaparte
as Venus Victrix, 1804-08

19. Jean-Auguste-
Dominique Ingres
La Grande Odalisque, 1814

44

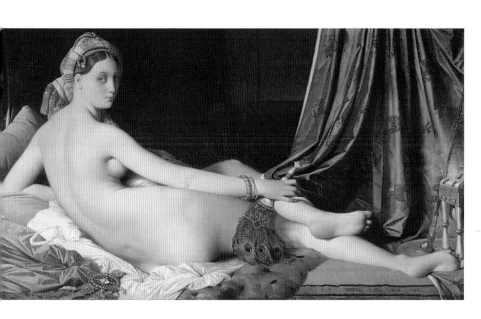

45

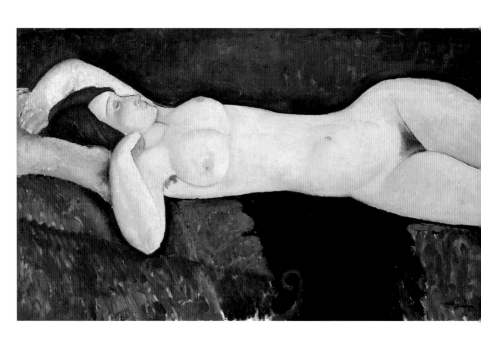

46

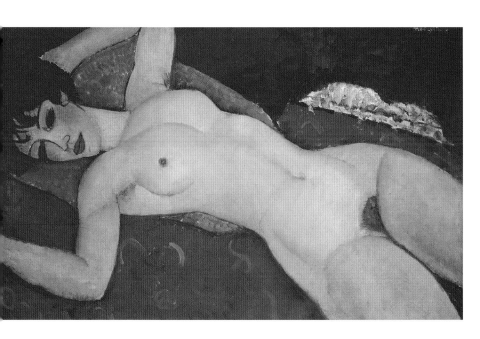

20. Amedeo Modigliani
Large Nude, 1917

21. Amedeo Modigliani
Red Nude, 1917

Following pages
22. *Eve*, 1130

47

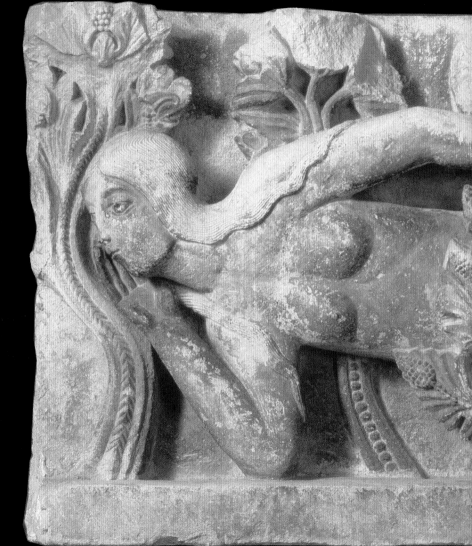

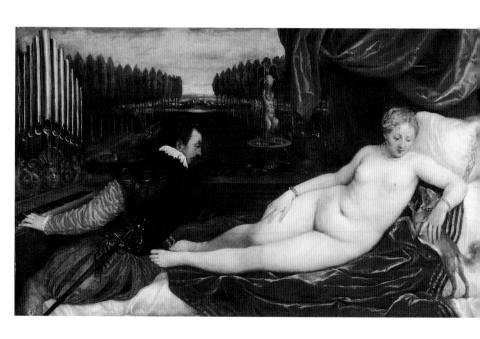

**23. Titian
(Tiziano Vecellio)**
Venus and the Organ Player,
1550-51

24. Francisco Goya
The Nude Maja, circa 1800

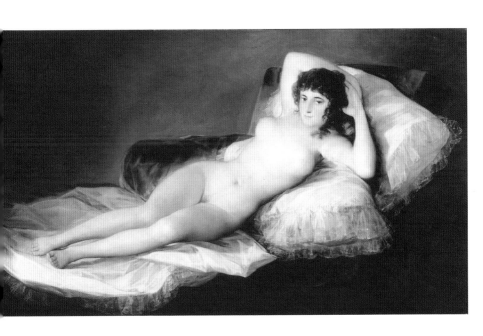

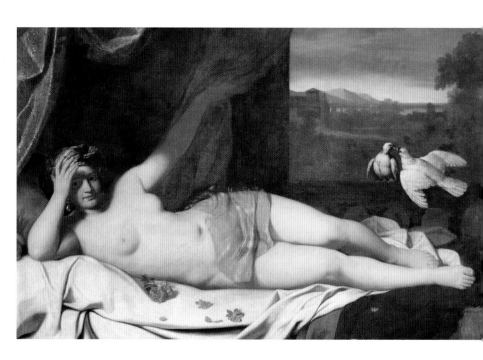

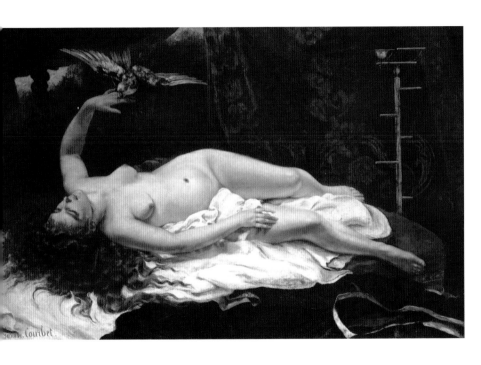

**25. Domenichino
(1581-1641)**
Venus

26. Gustave Courbet
Woman with a Parrot, 1866

Following pages
27. Gustave Courbet
Le Sommeil, 1866

53

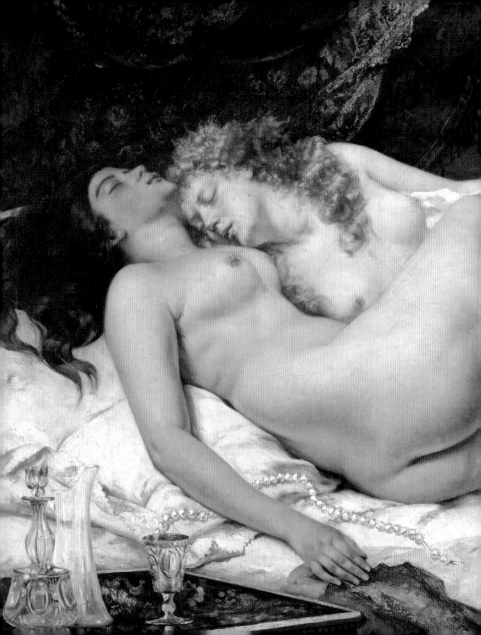

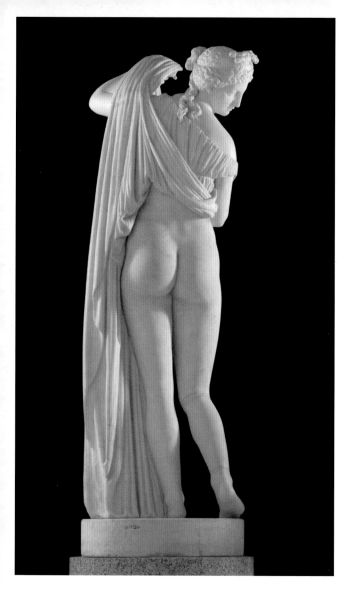

28. *Kallipygian Venus*
(whole and detail)

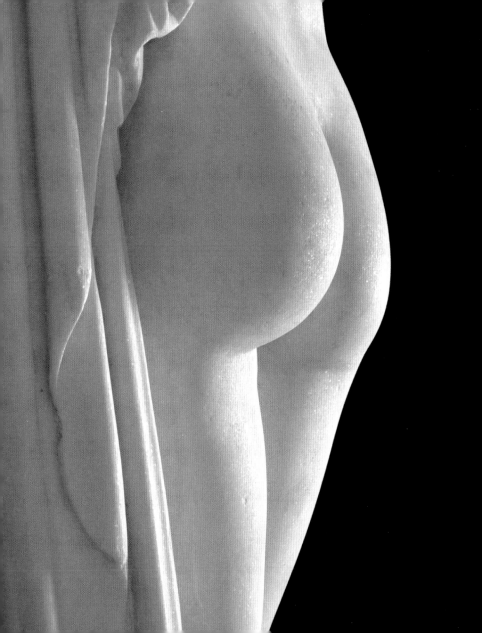

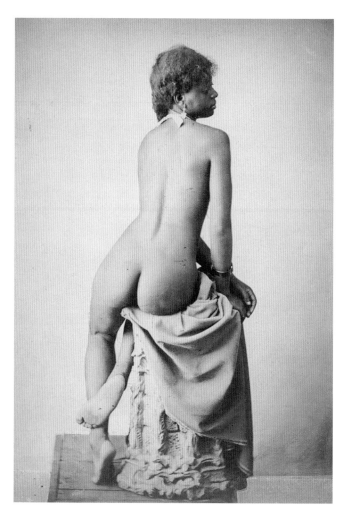

29. Anonymous
Female Nude, circa 1858

**30. Antonio Allegri
da Correggio**
Jupiter and Io, 1531-32

58

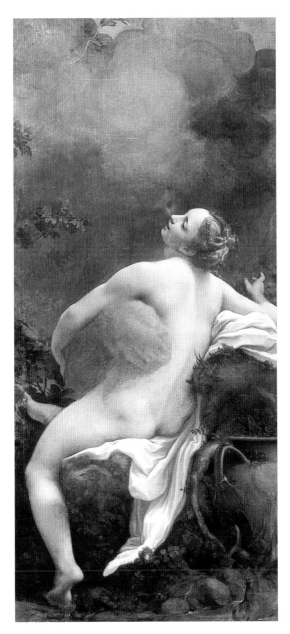

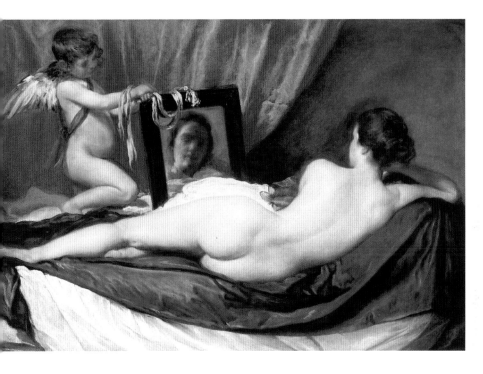

**31. Brassaï (pseudonym
of Gyula Halász)**
Nude, circa 1932

32. Diego Velázquez,
The Toilet of Venus
(*The Rokeby Venus*),
circa 1650

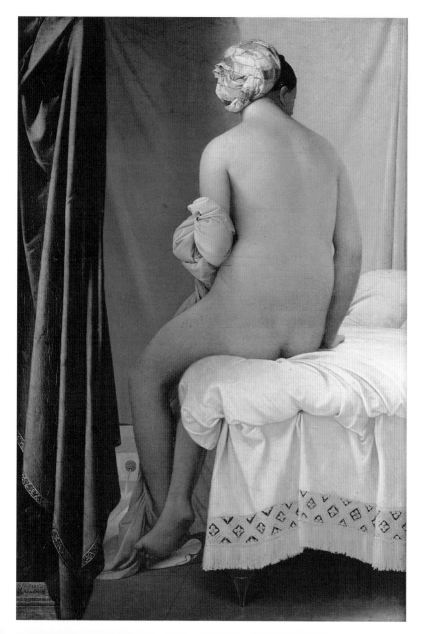

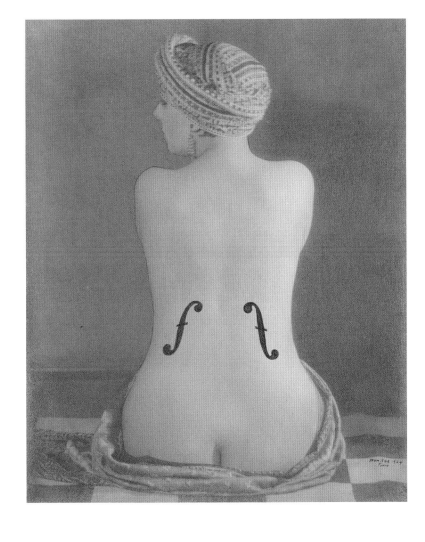

**33. Jean-Auguste-
Dominique Ingres**
Valpinçon Bather, 1808

34. Man Ray
Le Violon d'Ingres, 1924

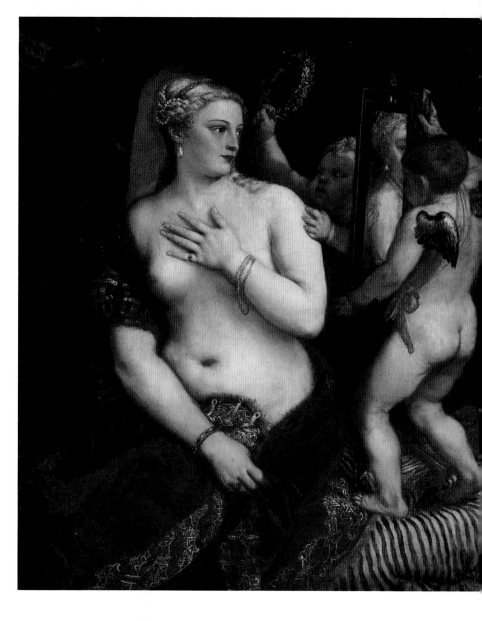

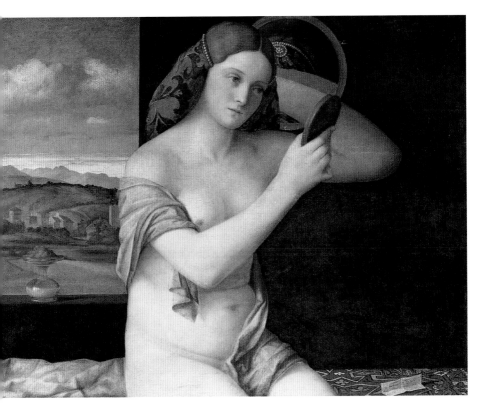

**35. Titian
(Tiziano Vecellio)**
*Venus with a Mirror,
circa* 1555

36. Giovanni Bellini
*Naked Young Woman
in Front of the Mirror,* 1515

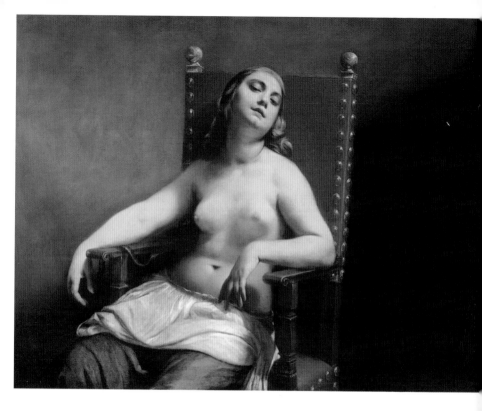

37. Guido Cagnacci
Cleopatra Dying, circa 1660

38. Guido Cagnacci
Cleopatra's Suicide, 1659-63

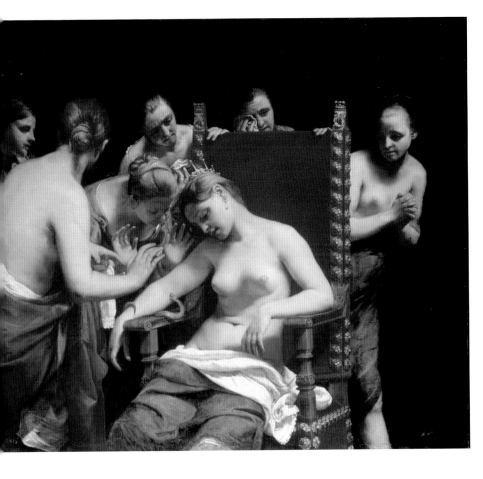

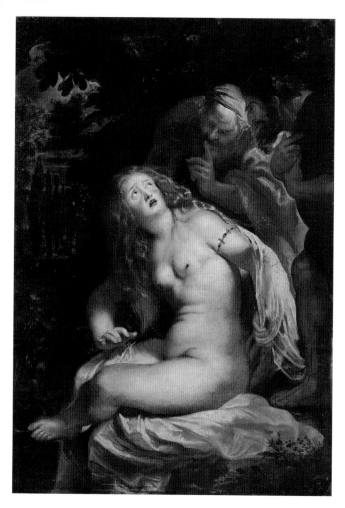

39. Pieter Paul Rubens
Susanna and the Elders,
1607

40. Artemisia Gentileschi
Susanna and the Elders,
1610

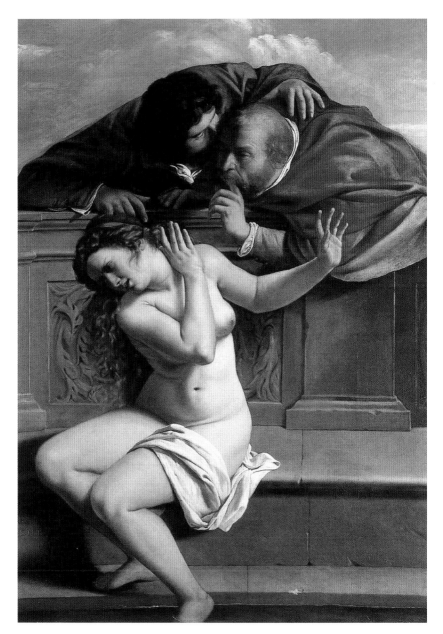

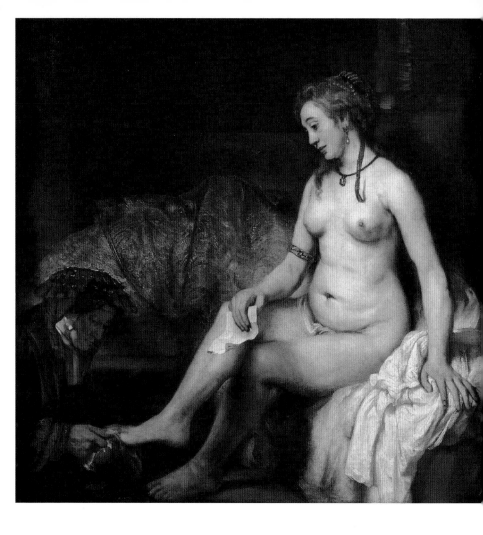

70

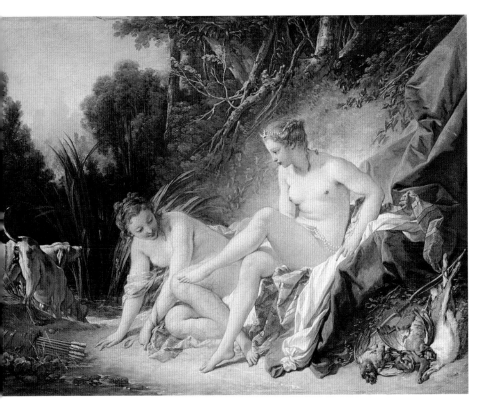

**41. Rembrandt
Harmenszoon Van Rijn**
*Bathsheba with King David's
Letter*, 1654

42. François Boucher
Diana Bathing, 1742

Following pages
43. Pierre-Auguste Renoir
Seated Female Nude,
circa 1876

44. Pierre-Auguste Renoir
Female Nude in a Landscape,
1883

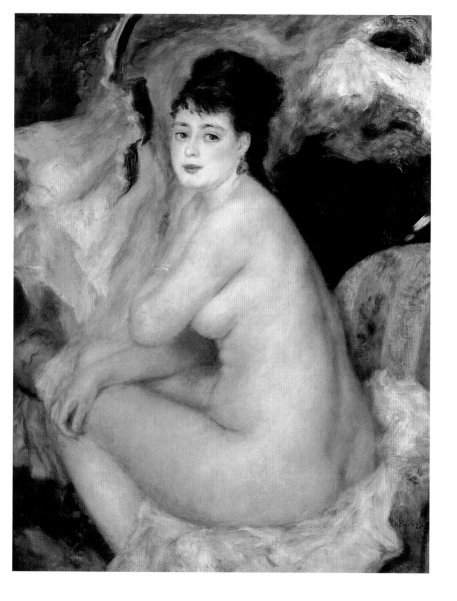

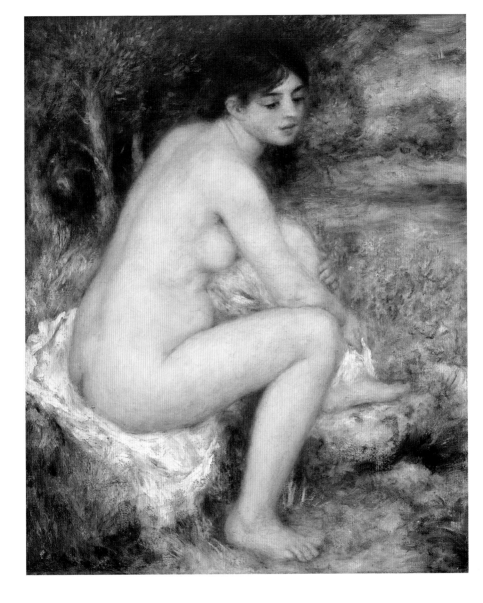

73

45. François-Antoine Vizzavona
*Portrait document for the painter Romaine Brooks,
circa* 1910

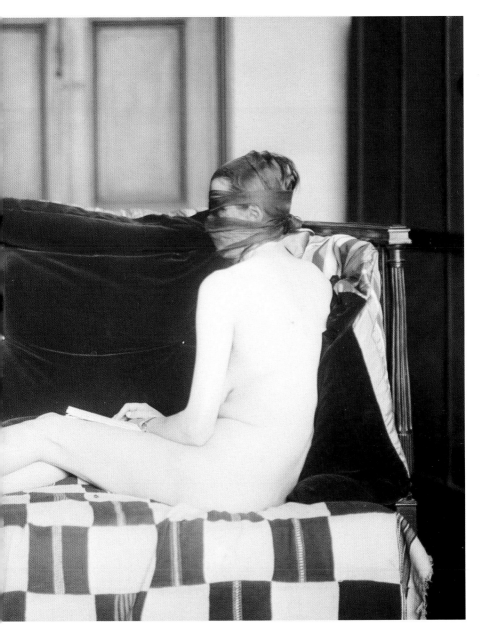

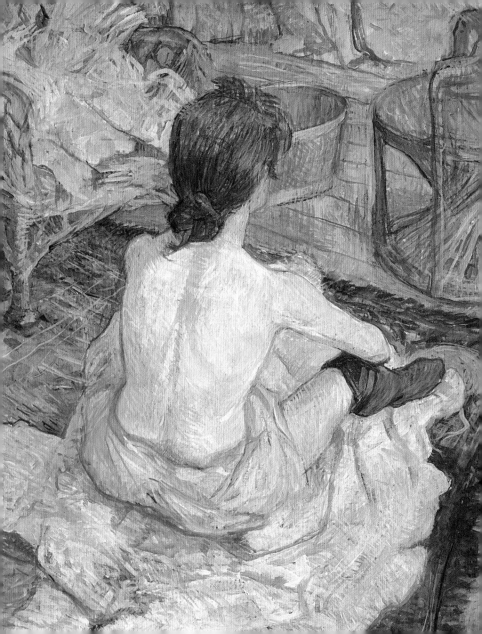

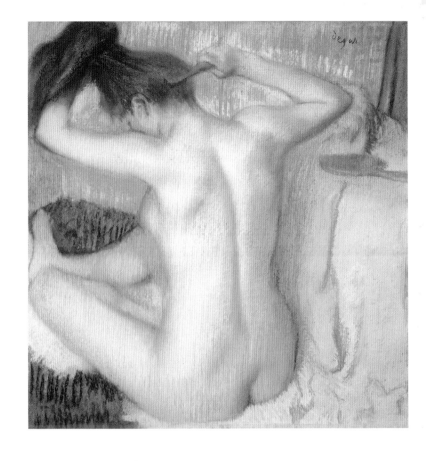

46. Henri de Toulouse-Lautrec
Woman Pulling up her Stocking, 1894

47. Edgar Degas
After the Bath, 1884

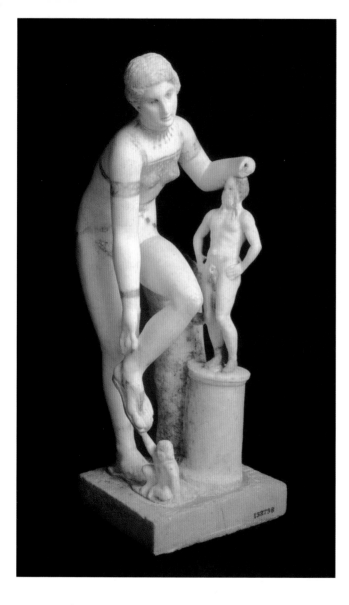

48. *Venus in a Bikini*
Roman copy after a
Hellenistic original of the
end of the 3rd century BC,
1st century BC – 1st century
AD

**49. Henri de Toulouse-
Lautrec**
*Woman Putting on
her Stocking*, 1894

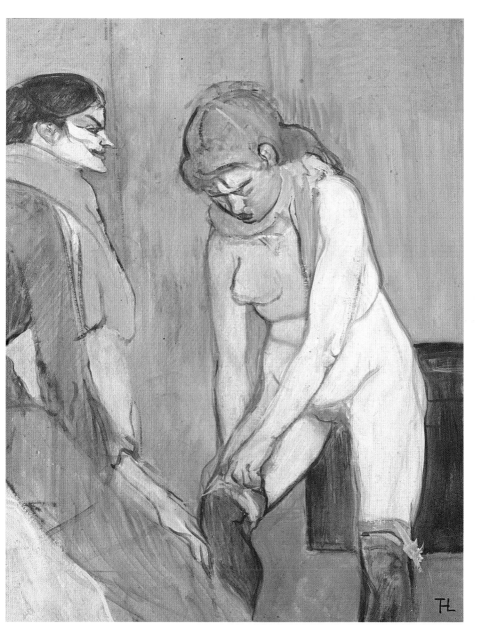

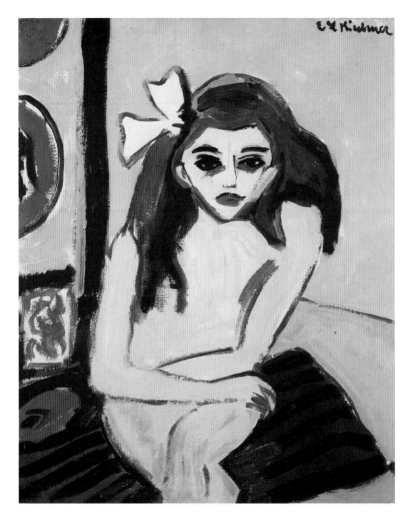

50. Ernst Ludwig Kirchner
Marcella, 1909-10

51. Edvard Munch
Puberty, 1893

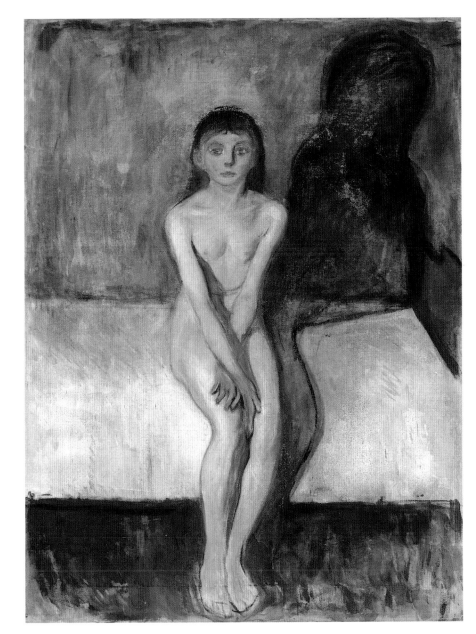

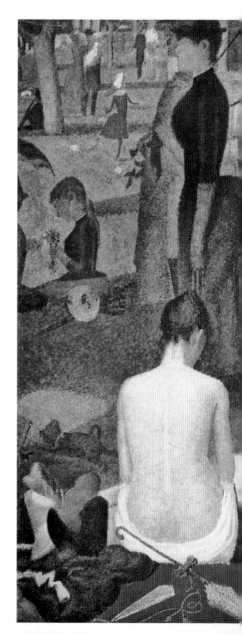

52. Georges Seurat
Les Poseuses (*Models*), 1888

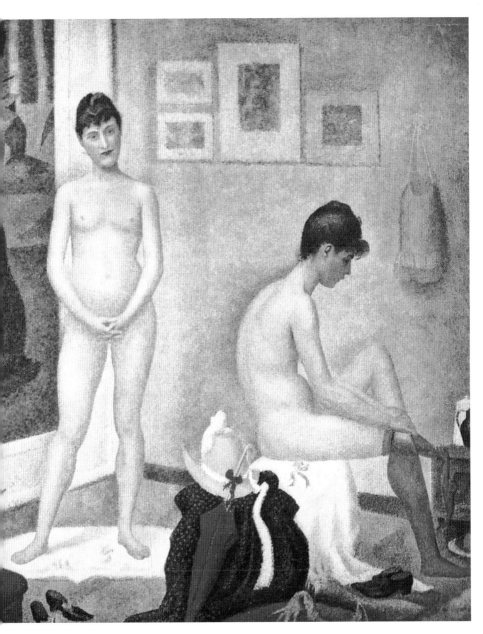

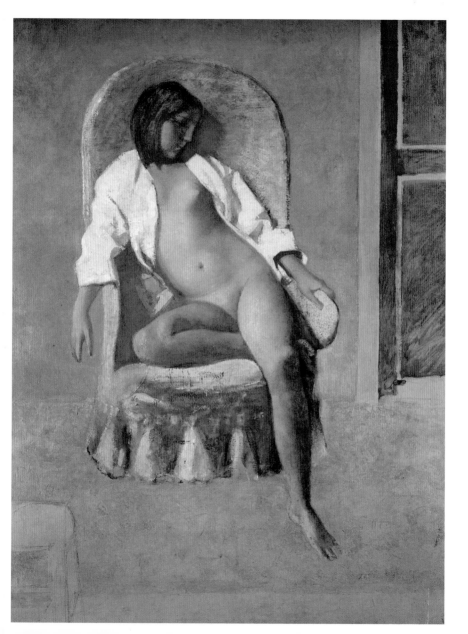

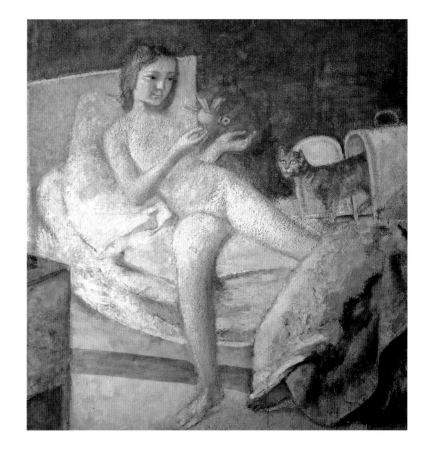

**53. Balthus
(Balthazar Klossowski)**
Nude Resting, 1977

**54. Balthus
(Balthazar Klossowski)**
Le Lever (The Awakening),
1975-78

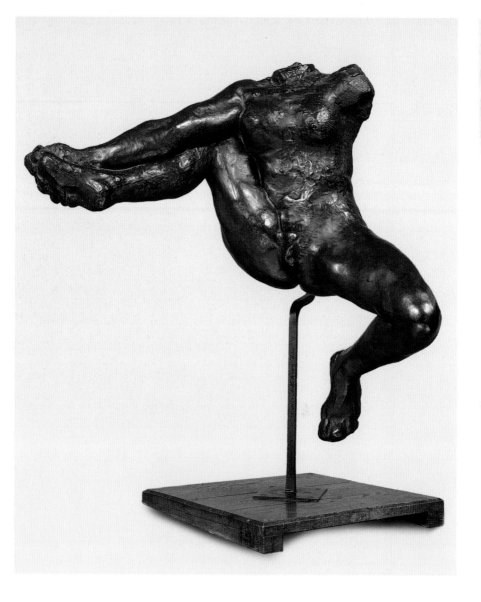

86

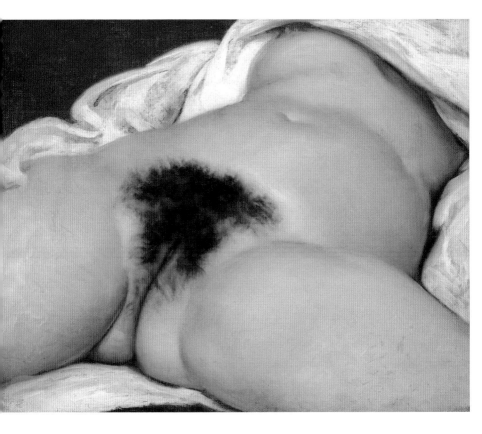

55. Auguste Rodin
Iris, Messenger of the Gods,
circa 1891

56. Gustave Courbet
The Origin of the World, 1866

87

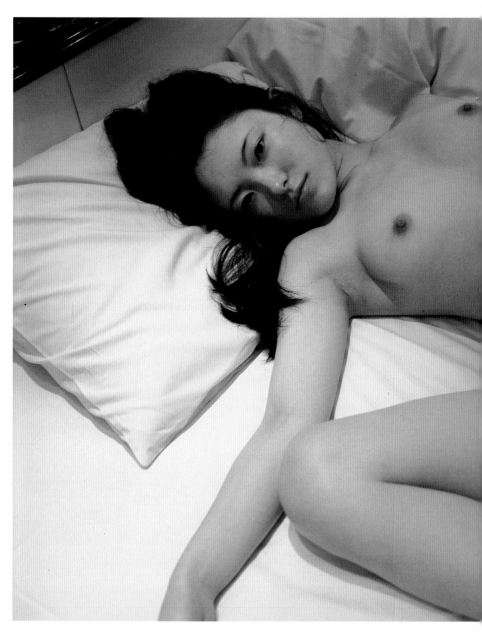

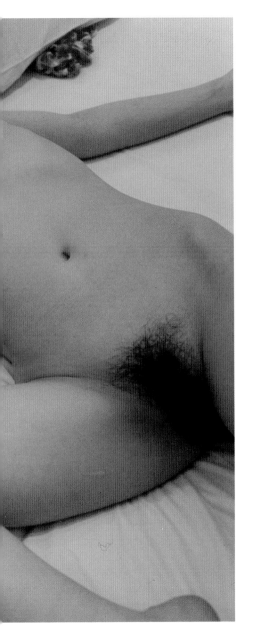

57. Nobuyoshi Araki
Kaori, 2002

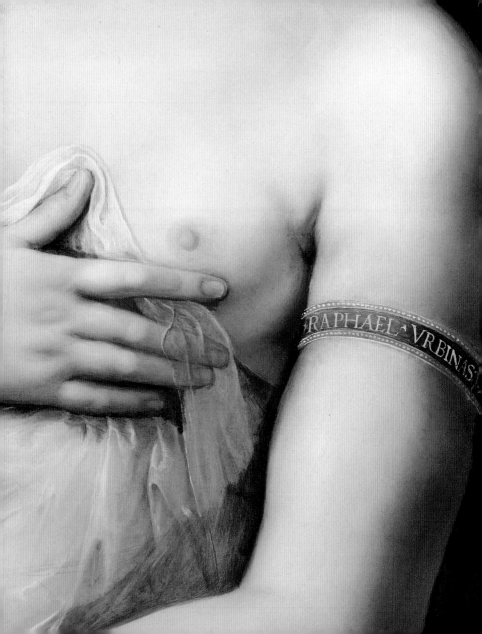

Appendix

Catalogue of the Works

1. *Knidian Aphrodite*
(*"Colonna Venus"*)
Roman copy of the original
by Praxiteles (*circa* 350 BC),
first half of 2nd century AD
Marble, height 205 cm
Vatican Museums,
Museo Pio-Clementino, Sala
delle Maschere, Vatican City

2. *Capitoline Venus*
Roman copy of the original
by Praxiteles from the 4th
century BC, Antonine Age
(142-93 AD)
Paros Marble, height
193 cm (including plinth)
Capitoline Museums, Rome

3. Sandro Botticelli
Birth of Venus, 1484
Tempera on canvas,
184.5 x 285.5 cm
Galleria degli Uffizi, Florence

**4. Marie Guilhelmine
Benoist**
Portrait of a coloured woman,
1799-1800
Oil on canvas, 81 x 65 cm
Musée du Louvre, Paris

**5. Raphael
(Raffaello Sanzio)**
Portrait of a Young Woman
(*La Fornarina*), 1518-19
Oil on wood, 85 x 60 cm
Galleria Nazionale d'Arte
Antica, Palazzo Barberini,
Rome

**6. William Adolphe
Bouguereau**
The Birth of Venus, 1879
Oil on canvas, 300 x 215 cm
Musée d'Orsay, Paris

7. Pasiteles or Stephanus
Esquiline Venus,
circa 46-4 BC
Paros Marble, height 155 cm
Capitoline Museums, Rome

8. Antonio Canova
The Graces, 1813-16
Marble, 182 x 103 x 46 cm
The State Hermitage
Museum, St. Petersburg

9. Pieter Paul Rubens
The Three Graces, 1638 (?)
Oil on canvas, 221 x 181 cm
Museo Nacional del Prado,
Madrid

10. Sandro Botticelli
Allegory of Spring, 1481-82
Tempera on panel,
203 x 314 cm
Galleria degli Uffizi, Florence

**11. Raphael
(Raffaello Sanzio)**
The Three Graces, 1505
Oil on panel, 18 x 18 cm
Musée Condé, Chantilly

12. Jean-Léon Gérôme
Pygmalion and Galatea,
circa 1890
Oil on canvas, 94 x 74 cm
Private collection

13. Jean-Léon Gérôme
Pygmalion and Galatea,
circa 1890
Oil on canvas, 89 x 68.9 cm
The Metropolitan Museum
of Art, New York

**14. Titian
(Tiziano Vecellio)**
Venus of Urbino, 1538
Oil on canvas, 119 x 165 cm
Galleria degli Uffizi, Florence

15. Édouard Manet
Olympia, 1863
Oil on canvas,
130.5 x 190 cm
Musée d'Orsay, Paris

16. Édouard Manet
Le déjeuner sur l'herbe, 1863
Oil on canvas, 208 x 264 cm
Musée d'Orsay, Paris

**17. Titian
(Tiziano Vecellio)**
Country Concert, circa 1510
Oil on canvas, 110 x 138 cm
Musée du Louvre, Paris

18. Antonio Canova
*Pauline Bonaparte as Venus
Victrix*, 1804-08
Marble, length 200 cm
Galleria Borghese, Rome

19. Jean-Auguste-Dominique Ingres
La Grande Odalisque, 1814
Oil on canvas, 91 x 162 cm
Musée du Louvre, Paris

20. Amedeo Modigliani
Large Nude, 1917
Oil on canvas, 73 x 116 cm
The Museum of Modern Art,
New York

21. Amedeo Modigliani
Red Nude, 1917
Oil on canvas, 60 x 92 cm
Mattioli Collection, Milan

22. *Eve*, 1130
Relief on stone,
Musée Rolin, Autun

**23. Titian
(Tiziano Vecellio)**
Venus and the Organ Player,
1550-51
Oil on canvas, 136 x 220 cm
Museo Nacional del Prado,
Madrid

24. Francisco Goya
The Nude Maja, circa 1800
Oil on canvas, cm 97 x 190
Museo Nacional del Prado,
Madrid

**25. Domenichino
(1571-1641)**
Venus
Oil on canvas,
121.9 x 168.9 cm
Museums Trust, York

26. Gustave Courbet
Woman with a Parrot, 1866
Oil on canvas,
129.5 x 195.6 cm
The Metropolitan Museum
of Art, New York
H.O. Havemeyer Collection,
Bequest of Mrs. H.O.
Havemeyer, 1929

27. Gustave Courbet
Le Sommeil, 1866
Oil on canvas, 135 x 200 cm
Musée du Petit Palais, Paris

28. *Kallipygian Venus*
(whole and detail)
Marble, height 152 cm
Museo Archeologico
Nazionale, Naples

29. Anonymous
Female Nude, circa 1858
Photograph
Dietmar Siegert Collection,
Munich

**30. Antonio Allegri
da Correggio**
Jupiter and Io, 1531-32
Oil on wood, 163.5 x 70.5 cm
Kunsthistorisches Museum,
Vienna

**31. Brassaï (pseudonym
of Gyula Halász)**
Nude, circa 1932
Photograph
Edwynn Houk Gallery,
New York

32. Diego Velázquez,
The Toilet of Venus
(*The Rokeby Venus*),
circa 1650
Oil on canvas, 122 x 175 cm
The National Gallery, London

33. Jean-Auguste-Dominique Ingres
Valpinçon Bather, 1808
Oil on canvas, 146 x 97.5 cm
Musée du Louvre, Paris

34. Man Ray
Le Violon d'Ingres, 1924
Gelatine silver print mounted
on paper, pencil, India ink,
31 x 24.7 cm
Musée national d'Art moderne
– Centre Georges Pompidou,
Paris

**35. Titian
(Tiziano Vecellio)**
Venus with a Mirror,
circa 1555
Oil on canvas,
124.5 x 105.5 cm
National Gallery of Art,
Washington

36. Giovanni Bellini
*Naked Young Woman
in Front of the Mirror*, 1515
Oil on wood, 62 x 79 cm
Kunsthistorisches Museum,
Vienna

37. Guido Cagnacci
Cleopatra Dying, circa 1660
Oil on canvas, 120 x 158 cm
Pinacoteca di Brera, Milan

38. Guido Cagnacci
Cleopatra's Suicide, 1659-63
Oil on canvas,
140 x 159.5 cm
Kunsthistorisches Museum,
Vienna

39. Pieter Paul Rubens
Susanna and the Elders,
1607
Oil on canvas, 94 x 66 cm
Galleria Borghese, Rome

40. Artemisia Gentileschi
Susanna and the Elders,
1610
Oil on canvas
Graf von Schönborn
Collection, Pommersfelden

41. Rembrandt
Harmenszoon Van Rijn
*Bathsheba with King David's
Letter*, 1654
Oil on canvas, 142 x 142 cm
Musée du Louvre, Paris

42. François Boucher
Diana Bathing, 1742
Oil on canvas, 57 x 73 cm
Musée du Louvre, Paris

43. Pierre-Auguste Renoir
Seated Female Nude,
circa 1876
Oil on canvas, 92 x 73 cm
Pushkin Museum, Moscow

44. Pierre-Auguste Renoir
Female Nude in a Landscape,
1883
Oil on canvas, 65 x 55 cm
Musée de l'Orangerie, Paris

45. François-Antoine
Vizzavona
*Portrait document for the
painter Romaine Brooks*
Photograph, *circa* 1910
Réunion des Musées
Nationaux, Paris
Druet-Vizzavona Fund

46. Henri
de Toulouse-Lautrec
*Woman Pulling up
her Stocking*, 1894
Turpentine oil on wood,
58 x 48 cm
Musée d'Orsay, Paris

47. Edgar Degas
After the Bath, 1884
Pastel, 50 x 50 cm
The State Hermitage
Museum, St. Petersburg

48. *Venus in a Bikini*
Roman copy after a
Hellenistic original of the
end of the 3rd century BC,
1st century BC – 1st century
AD
Marble, 62 x 22,7 x 21,8 cm
Museo Archeologico
Nazionale, Naples

49. Henri
de Toulouse-Lautrec
*Woman Putting on her
Stocking*, 1894
Turpentine oil on card,
58 x 48 cm
Musée d'Orsay, Paris

50. Ernst Ludwig Kirchner
Marcella, 1909-10
Oil on canvas, 71.5 x 61 cm
Stockholm, Moderna Museet

51. Edvard Munch
Puberty, 1893
Oil on canvas, 149 x 112 cm
Munch-museet, Oslo

52. Georges Seurat
Les Poseuses (*Models*), 1888
Oil on canvas,
199.5 x 250.5 cm
Barnes Foundation, Merion

53. Balthus
(Balthazar Klossowski)
Nude Resting, 1977
Oil on canvas, 200 x 150 cm
Private collection

54. Balthus
(Balthazar Klossowski)
Le Lever (*The Awakening*),
1975-78
Oil on canvas, 169 x 159.5 cm
Private collection

55. Auguste Rodin
Iris, Messenger of the Gods,
circa 1891
Bronze, 82.7 x 69 x 63 cm
Musée Rodin, Paris

56. Gustave Courbet
The Origin of the World, 186
Oil on canvas, 46 x 55 cm
Musée d'Orsay, Paris

57. Nobuyoshi Araki
Kaori, 2002
Photograph

Selected Bibliography

P. Richer, *Le Nu dans l'art*, Paris 1925-1926

J. Cassou, *Le Nu dans la peinture européenne*, Paris 1952

K. Clark, *The Nude: A Study in Ideal Form*, Princeton 1972

M. Cormack, *The Nude in Western Art*, Oxford 1976

B. Noël, *Le Nu*, Paris 1986

I. Bogdanova, *The female nude in art photography*, Moscow 1992

L. Nead, *The female nude: art, obscenity and sexuality*, London-New York 1992

S. Aubenas, *L'art du Nu aux XIX siècle*, Paris 1997

J. Hedgecoe, *Figure and Form: Photographing the Nude*, New York 1996

A.H. Bitesnich, *Nudes*, Thalwil 1998

T. Flynn, *The body in Three Dimensions*, New York 1998

T. Mitchell, *The female nude. A private view*, London 1999

L. Nochlin, *Representing Women*, London 1999

F. Jullien, *De l'essence ou du Nu*, Paris 2000

Ch.H. Hallett, *The Roman Nude*, Oxford 2005